The Kiss of Apollo

The Kiss of Apollo

PHOTOGRAPHY & SCULPTURE 1845 TO THE PRESENT

Essay by Eugenia Parry Janis

FRAENKEL GALLERY

IN ASSOCIATION WITH BEDFORD ARTS, PUBLISHERS

SAN FRANCISCO

Contents

Introduction

I CAN'T BE CERTAIN of the year, but I remember clearly the experience of seeing Fox Talbot's *Bust of Patroclus* (plate 2) for the first time. Plainly no more than a plaster depiction, the bearded warrior in Talbot's photograph nevertheless contained a startling sense of life and breath. The vacant eyes, intense and alert, were disquieting in the same way that those of Strand's *Blind Woman* would be seventy years later. But it was the *enlivened* aspect of the sculpture, the persuasive quality of animation that it could not achieve in actuality, that caused the greater wonder.

That wonder persists, and in retrospect it seems appropriate that Talbot's *Patroclus,* one of the first transcendent photographs of sculpture, should have suggested the idea for this book. That the camera, used with intelligence, can give uncanny life to inanimate objects is something recognized and examined by a long list of Talbot's photographic descendants, to a variety of ends. Here, through forty-one of their photographs, each specifically addressing figurative sculpture, and sequenced to parallel the development of the medium, this book intends to explore aspects of the photographer's enlivening gaze. It also investigates the ways in which new meaning can be created when one artist meditates on the work of another.

For the most part the images are relatively little known, and I determined early on that no photographer would be represented by more than one work. (The late discovery of Charles Nègre's seductive daguerreotype [plate 1] required an exception.) A small selection of pictures precludes any attempt at comprehensiveness; at best it can only hint at the broad range of possibilities that a century and a half of photographic exploration has uncovered. The selection is ultimately personal, accounted for, I suspect, by an inability to fully resolve the challenges of these pictures, and the corresponding need to return to them. Toward that end I've enlisted the abilities of Eugenia Parry Janis, a writer whose insights into the implications of photography make her an ideal collaborator in addressing this rich and mysterious subject. Beyond that, I defer to the enlightened advice of the late Sam Wagstaff, and suggest that this book is finally about "the pleasure of looking, and the pleasure of seeing."

— *J. F.*

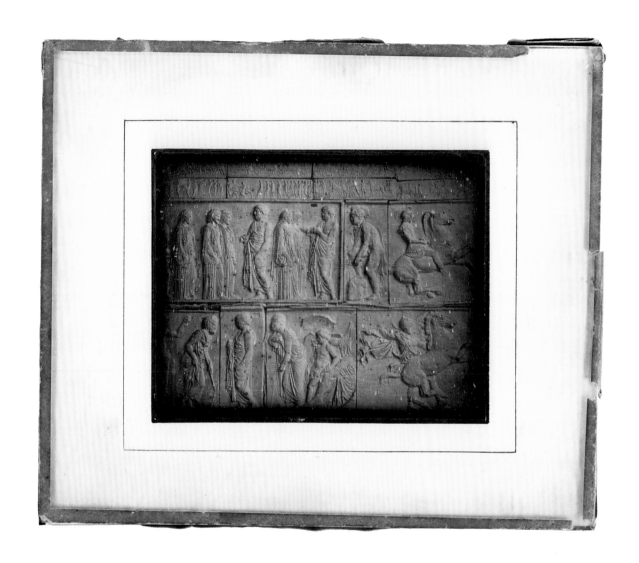

CHARLES NÈGRE

A Collection of Plaster Casts

ca. 1845

daguerreotype

2⅞ x 3⅝″ in 5 x 6″ mount

Fabled Bodies

SOME OBSERVATIONS ON THE PHOTOGRAPHY OF SCULPTURE

> "Sculpture is patience. This art does not speak to you;
> it waits for you. . . . It is in no hurry."
> AUGUSTE RODIN, *The Cathedrals of France*

SCULPTURE SEDUCED PHOTOGRAPHERS from the beginning. The languor of its sublime inanimacy made the decision of what to photograph easy. Viewed by the first camera technicians, sculpture became "the triumph of the apparatus,"[1] for the milky luminescence of marble or plaster casts required few trade-offs. There were no light-absorbing densities, like grass or green leaves, to further confuse the foundering chemistries, no cloudless skies to burn the salts into visual incomprehensibility, no sitters' complaints of harsh lines turning their faces cadaverous in the prime of life.

The sculpture that the earliest photographers had around them was largely of the tabletop variety, and during the 1830s, as these experimenters turned to gaze at the supple contours of their beloved figurines, they turned roofs, mantels, and windowsills into the first theaters of photographic fascination in order to explore the secret power of appearances. Thus, at a moment of dubious technical certitude, sculpture was photography's best substitute for the human presence when the most telling symbols of modern life were contemporary portraiture and the ever-fluctuating panorama of the passing crowd. Sculpture played another role, too, being one of the few available sources that allowed photographers to gaze at idealized forms from other times and places, the very remoteness of which continued to fan the flame of romantic longing.

In turning to the modeler's art, the earliest photographers turned away from incident and gazed inward by meditating on the contours of implacable profiles, milky shoulders, torsos, and thighs. They noted the revelation of temperament in dilated pupils or creased brows while they caressed their sleeping models with time-lapse chiaroscuro. As photographed, these bodies became outlines of gestures that seemed to have descended to earth from the temples of celestial memory; their very translucency whispered a language of white silence.

Poets in the nineteenth century reveled in such imaginative leaps, well before photography was born, by wrapping the sculpture they loved in literary rays of light, as Byron did in *Childe Harold* with the Apollo Belvedere:

The god of life, and poetry, and light
The Sun, in human limbs arrayed, and brow
All radiant . . . ; in his eye
And nostril, beautiful disdain, and might
And majesty flash their full lightnings by,
Developing in that one glance the Deity.[2]

Few photographers in England or all of Europe would have been immune to Byron's conception of the relationship between sculpture, sunlight, and divinity. And they fell in love with sculpture before the lens the way Byron fell in love with the figure of Apollo. If many camera translations caused the "lightnings" and "radiance" to disappear, the new artists reinvented the original illumination by warming their prints with baths of ammonia, old hypo, or gold chloride. Inspired by classical affections, photographers transformed the peculiar fancies engendered by the modeler's art with the magic of chemistry.

It should be mentioned at the outset that the fancies which sculpture inspired in photographers have hardly altered in our own time. The desire to render sculpture with a camera seems to be based on the same peculiar confluence of motives today as at photography's origins. Among hundreds of marbles languishing in The Great Exhibition of 1851, the white thighs of Philip Henry Delamotte's rendition of *"Night"* (plate 9) recur with explicit connection to a departed dreamer in Clarence John Laughlin's *A Vision of Dead Desire*, 1954 (plate 27). And they reappear with the self-consciousness of one who feels the temptations of the flesh, despite all indications to do otherwise, in Bill Dane's Los Angeles collection of truncated "lovers" from 1974 (plate 34).

For students of art and art history, past and present, photographing sculpture has always served a practical function as well. When Charles Nègre daguerreotyped a group of plaster reliefs (plate 1), he was probably following the advice his teacher, Paul Delaroche, gave to all his painting students in the early 1840s, that they not fear the arrival of photography but rejoice in the camera as a sketching tool. Delaroche regarded photographic science as the best possible ally in allowing artists to see better than the eye itself. Nègre's daguerreotype reduces the ancient motifs into a miniature encyclopedia from which a young copyist might find inspiration in contemplating the ideal gestures of the past, grazed by light as if by a feather, and encapsulated into an artist's keepsake. Roger Fenton's *Barbarian Captive, British Museum* (plate 5) also expresses the desire to provide an art-hungry public with records of supreme achievements, as does Adolphe Braun's view of Michelangelo's *"Night," Medici Chapel, Florence* (plate 15). This image is greatly enhanced by the relieflike surface imparted by carbon printing, which like a strange cosmetic subliminally restores to the print an illusion of the three-dimensionality of the original.

Photography's simple motive to record and preserve sculpture has been challenged continually in the process of changing tactile forms into two-dimensional equivalents. It is no accident that Rodin included Steichen, a photographer demonstrably fearless where the camera art's love of obfuscation was concerned, among those who would "interpret" his masterpieces, such as *Balzac* (plate 18). Nor is it surprising that Brancusi became one of the most poetical photographers of the twentieth century simply by following the light that alternately defined and dissolved his own sculpted forms. The sculptor/photographer had no difficulty in conceding much of the physical substance of *The Golden Bird* (plate 20), with its highly polished surface, to the shape of reflected light. Thus, at times the photography of sculpture could be aided and abetted by the sculptors themselves, who knew enough about the role of sacrifice in their own art to understand how it might convey the true spirit of an original in translation. In both Steichen's *Balzac* and Brancusi's *Golden Bird* we have originals completely reconceived through being photographed.

In viewing these recreations, we should be cautious about supposing that, in the course of preserving sculpture with the camera, interpretations of the modeler's art necessarily "advanced" alongside photography's technical refinements and art's increasing abstraction in the twentieth century. The story of photography's love affair with sculpture is much more complicated by virtue of its lack of progress, that is, in seeming to ignore motives that might conform to developments in any particular artistic direction.

To confront sculpture with a camera endures as a primitive passion, absolutely wedded to the most elemental reasons for photographing at all. When Andy Warhol explodes a flashbulb on a rigid figure from Cyprus in the Metropolitan Museum of Art and then sews together four identical prints of the image like a patchwork quilt (plate 37), he reminds us of the celebrity of sculpture as an artistic genre, that its rhetoric can be as public and repetitious as a sheet of postage stamps. By making snapshots of the perpetually smiling, bearded man, as if the figure had entered a photo booth, Warhol reminds us, too, of how naked sculpture may become depending on the gaze—that it is subject to whatever we care to bring to it, which in the end may be practically everything the modern imagination can dream up. But especially photography of sculpture reveals undreamed-of sides of the conjuring mind in its power to elucidate private lives lodged within dormant materials. How this occurs we may appreciate from the first moments of photographic seeing.

In Paris, around 1837, before he announced his invention of daguerreotype to the Académie des Sciences, Louis-Jacques-Mandé Daguerre, a painter and the director of a light theater called the Diorama, arranged plaster of Paris casts on a window ledge

FIGURE 1
LOUIS-JACQUES-MANDÉ DAGUERRE
Still Life, 1837
Daguerreotype
Société Française de Photographie, Paris

FIGURE 2
HUBERT
Untitled, 1839
Daguerreotype
Present location unknown

in his studio overlooking the boulevard du Temple (fig. 1). His aim was quite simple: to demonstrate on a sensitized metal plaque how sunshine fell on the surfaces of ordinary things. Among the plaster casts in Daguerre's display is a canteen of woven straw, which the daguerreotype describes intricately. Despite the full daylight beyond the window, the arrangement sits as if at the mouth of a cave; light and shadow graze a plaster relief, define with stronger chiaroscuro the supple contours of two plaster putti's winged heads, and nearly bury a goat's head and that of a sheep in shadow. In another arrangement, Daguerre's collaborator, the painter and architect Hubert[3] illuminated a plaster torso of the Venus de Milo like a voyeur enthralled by the actual flesh of a living model (fig. 2). In these experiments to make daguerreotype chemistries "tell," things "radiate and wear themselves out in the game of appearances," as Baudrillard observed,[4] for the objects, positioned to reveal things as they are, remain mysterious and insoluble. There is nothing to do but love them and be amazed.

To photograph sculpture at first was more like drawing from the model than photographing anything else. (Undoubtedly, Nègre felt this in making his daguerreotype.) William Henry Fox Talbot fairly crowed when he realized that photography could be "the royal road to drawing" because it seemed to his practical intelligence to make perspective so easy and spared lazy artists copying endless details.[5] François Arago had extolled such time-saving features in 1839 in his report on the daguerreotype to the Académie des Sciences.

When Talbot struggled to render a small plaster cast of the Hellenistic Laocoön group, he ended up with a cut-out configuration, which in the negative especially (fig. 3) looks more like a Roman cameo or a porcelain relief by Thomas Wedgewood than the original tragedy in stone. Talbot's difficulties made it clear that photographing sculpture so changed the work from its original palpable existence that as an image it seemed practically reinvented. Every photographic rendition of a sculpture would seem to be less of a record than a reexamination of the work that re-presents it, as in music. Even a photograph that fails to tell or incompletely represents the object in question may allude to some essential part of the original. Viewing Talbot's silhouette of the Laocoön, the extremities of which crawl with serpents, and arms, and legs, we are more aware than ever of the horrifying destiny of this priest of Apollo.

It is not with the Laocoön but with Talbot's rendition of a plaster bust depicting Patroclus[6] (here plate 2, a variant of plate 5 in his first published book of calotypes, *The Pencil of Nature*, 1844–46), that the amateur, in instructing others about how to photograph sculpture, demonstrated his awareness of how recreative the process can be. His image after the reproduction of a Hellenistic bust idealizing the warrior and friend of Achilles obviously solves the problem of capturing the full effect of plaster of Paris in the round. Talbot asserts that "busts and other sculpted specimens" are good subjects because of their whiteness at a time when "the photographic art" needed unusual amounts of light to awaken the sleeping chemistries.

But the inventor soon moved past these technical questions. What enchanted him in photographing sculpture were the seemingly endless ways in which a single object might be made to *change appearance* in the camera's light theater. Talbot's text accompanying the first of two Patroclus images included in *The Pencil of Nature* delves into the "immense difference in the effect" of one piece, depending on the angle of the light, the closeness or distance of the camera to the object, and, of course, the innumerable angles from which the sculpture might be captured on the negative. Note how plate 5 in *Pencil* (fig. 4) compares with its larger variant in the present volume (plate 2)—how in the latter the glance seems more anguished, "quickened" through its translation in the slightly different angle of vision and the light; how the hero's face seems more pointedly to testify to his mythical trials and sacrifices.

These observations of the way one kind of subject matter changes depending on the circumstances of its exposure to the lens are commonplaces to us today, hardly worth mentioning, yet many photographers continue to take them to heart in exploiting the expressive potential of sculpture, as we have seen Steichen do with Rodin and Brancusi accomplish with his own work. Talbot ventured to turn his plaster bust on its axis to achieve three-dimensional fullness and the most poignant mask possible in the prevailing illumination. He probably waited for cloudy weather rather than sunshine's flattening effect, for he noticed that strong light's shadows "confused the subject."[7] As a result, Talbot makes the viewer confront more than sculpture. By discovering an angle of vision that seems to narrate rather than to record, he intensifies the tragic emotion of the already anguished face to which we supply details of the Trojan War and Patroclus' grievous vulnerability.

Although such imaginative projections are part of what we expect from contemporary photographers, it is important to note that photography's earliest practitioners made these leaps first. Sculpture for all well-educated connoisseurs was thus more than an art of placidity and stasis. Ancient works, like the classical orders of Greek architecture, embodied unchanging canons of ideal beauty and proportion. But for a student of classical languages and literature, such as Talbot, it also had the power to elicit the profound emotions of heroism and human sacrifice essential to myth.[8] That ancient sculpture (even in reproduction) might reveal undreamed-of psychologies by virtue of the way light fell upon it, any connoisseur could have testified to from experience. These were things recognized over the centuries by many who had witnessed the apparitions possible through sculpture seen not only in daylight but in firelight, and moon glow.

Now an instrument of science had begun to evolve formulas (for exposure, camera position, distance, and closeness) through which a sculptor's intentions might be revealed and fixed for further study. If these technical factors seemed to explain how to experience the truth of a work of art more deeply, we are being deluded. Talbot never made any such claims. His science of photographing sculpture explains nothing

FIGURE 3
WILLIAM HENRY FOX TALBOT
Laocoön, ca. 1840
Paper negative
André and Marie-Thérèse Jammes, Paris

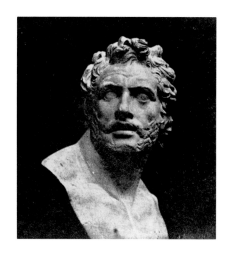

FIGURE 4
WILLIAM HENRY FOX TALBOT
Bust of Patroclus, 1842
Salt print from paper negative
The Pencil of Nature, pl. 5

of the kind. Light and shadow act as if to reform the work; their mercurial effects suggest a variable language, but the romantic longing for mystery and variability in photographic translations persists, above all, in order to mirror the fantasies of their recorders, then as now.

Another among the first sculptural dreamers was Hippolyte Bayard, the third "inventor" of photography. In the early spring of 1839 he began to make direct positives on paper and soon was recording the windmills of Montmartre like some romantic Don Quixote. He also toyed with small classical figurines in plaster of Paris at home and on the roof of the Ministry of Finance where he worked. These studies of sculpture were no less quixotic as camera subjects, for he grouped them together into *conversazioni* or showed them from behind about to dissolve into a haze. In this way he transposed the idealized antique beauty in sculpture reproductions into the current taste for *imagerie galante*, that innocent, provocative sexuality that infected so many popular lithographs of the 1830s. Bayard presents one late classical figurine from behind at some distance as if he were a voyeur concealed in the model's boudoir (fig. 5). What charming allusions to seduction he creates in miniature with the little sculpture. The female form appears to turn away from his prying eyes and, as if unaware of his presence, bends forward to adjust the garment that assures her modesty. Bayard included these classical reproductions in his first photographic self-portraits, where the casts assume the power of muses as they surround him with embraces and kisses.[9]

Every great nineteenth-century photographer who looked at sculpture follows in the spirit of these first fascinations. How strange John B. Greene's little figure of the wife of Ramses III at Thebes (plate 3) looks in this regard. She hardly comes up to the Pharoah's kneecap and is a detail perhaps overlooked in viewing the complex as a whole. But Greene's vision is seductive: even if such a picture were especially commissioned or found to round out the young archaeologist's documentation of Egypt, it nonetheless recalls Bayard's enchantment with the small, seductive female sculptures on his roof and tabletop. In Charles Aubry's *Still Life with Putto* (plate 11), the plaster baby resting against a jar of lilacs seems about to escape from the plaster scrollwork that holds him like a plant's new bud. His plump torso accompanies the arrangement of objects as another version of its floral enthusiasms, further demonstrated by the decorations woven into the cloth, the painted flowers sweeping the jar, and of course the aromatic freshness of the lilacs themselves.

In playing with sculpture Bayard had introduced a notion that remained latent in Daguerre's arrangements but that many photographers over the past 150 years have pursued with great concentration. This is the curious manipulation of the human form through photographic viewpoints that cause a sculpture's gestures to appear to act out

a story that lies outside of the intended subject of the work itself. Such a notion does not arise in the intimate vantage point of Greene or in Aubry's desire to unite the roly-poly forms of an infant with those of newly sprung nature. Rather we refer here to an intimate "situation," which photographers would appear to have contrived between themselves and the piece in question.

Many photographers since Bayard have entered into such private delusions with sculpture. Some appear to have confronted the modeled pieces as if they were fellow players in psychodramas of the photographer's making. At Versailles, Eugène Atget stood before the decorative allegorical figure of *Winter,* with its attribute of pinecones (plate 19), in such a way that the sculpture's expression conveys the severity of the season by also calling to mind the expression of a homeless indigent drawing his cloak more tightly around him in the shelter of a Paris doorway. This kind of imaginative leap is given literal existence in David McDermott and Peter McGough's 1988 portrayal of *Augustus in Modern Vestments, 1907* (plate 39), in which the serene expression of the emperor is reinterpreted from its original function as a symbol of Roman peace and prosperity, with the aid of a bow tie, celluloid collar, and linen jacket, to conform to the artists' own conception of Augustus' features as the prototype of Edwardian gentility.

Notice how Berenice Abbott's view of the wrapped and bound sculpture of Father Duffy in Times Square (plate 22) begins to resemble the vantage point of a public lynching, with the statue as some impossible victim about to pay for a crime. Then there is the deliberate distance that Lee Friedlander establishes between himself and the statue of General George Rogers Clark (plate 30), which, in pointing toward what seems to be the Ohio River in Louisville, looks over its shoulder and seems secretly and exclusively to communicate with the photographer. The same sense of the photographer's privileged connection with his subject occurs in Richard Benson's tribute to Saint-Gaudens' monument to Robert Gould Shaw and the Fifty-Fourth Massachusetts Volunteer Infantry, the first black volunteer regiment in the Civil War (plate 31). After carefully surveying the entire tableau from a distance, Benson edges so close to each profiled soul that with his probing light and lens he is cheek-to-jowl with the volunteers, witness and participant in a doomed march of yearning spirits.[10] By contrast, in Robert Adams' *Monument to Striking Miners and Their Families Killed in 1914 by the State Militia, Ludlow, Colorado* (plate 36), the photographer appears to have no interest in representing the memorial as a whole. Rather, he places himself in relation to one figure, as if he were about to whisper something into the sculpture's ear or the better to grasp an unfathomable message from the stone. The figure of the man with rolled-up shirtsleeves is viewed so that he turns away from the camera toward the light, a lost profile that acts like a barrier against the approaching photographer. In such scenarios, the photographer does not position himself merely as a documenter

but would seem to share the pedestal with the figure in the monument. It is as if Benson himself were a Civil War volunteer and Adams a dead miner, projections that give their images a quality of sadness beyond description. In exactly the same spirit, Herbert List in *Plaster Casts of Classical Sculptures in the Ruins of the Destroyed Academy of Arts, Munich, Winter,* 1945–46 (plate 25) found a vantage point that allowed him to join the fraternity of naked "prisoners" abandoned in the snow-dusted refuge so that his image, which at first seems like a playful coincidence between nude forms and a harsh season, becomes a metaphor of horror and desolation.

Recording sculpture with a camera thus has the power to join human beings in special pacts with objects. This could be said of all photography, of course. But in this projecting mode the camera artist not only registers the thing but records it with the explicit aim of showing that he has made a contract with it. This may seem heroic, but it can have fraudulent or ironic sides as well. A photographer will show the sculpture talking back, reaching out, furtively or fecklessly, toward us, mirroring a general purposelessness: W. A. Mansell discovered in the British Museum around 1865 (plate 14) that seemingly undirected gestures can elicit the kind of empathy we associate with the randomness of public experience. In museums we may become involuntary witnesses to the dance of a satyr, spy on a philosopher lost in thought, and marvel at the masculine finery of women warriors, all in the same glance. When Dimitris Constantine made his early photographic documents of the Parthenon Frieze on the Acropolis in Athens (plate 13), he was fortunate to be able to get closer to them than most ordinary viewers could. The frieze is meant to be seen from yards below, but suddenly viewing it straight on we sense that the gods have descended to earth at last. There they are, conversing as if in the relaxed atmosphere of our own parlors. Other places of public viewing, such as parks, where Atget, Friedlander, Benson, and Adams loved to find subjects, become arenas for similarly strange transmogrifications. Charles Nègre makes us appreciate more than a beautiful configuration of eighteenth-century sculpted arabesques in *Boreas Lifting Orythia* (plate 7). Rather, as strollers in the Tuileries, we become involuntary witnesses to the spectacle of a woman spirited away from her presumed attacker by a miraculous winged savior, an electrifying human drama that would have been performed perpetually in all seasons. William Eggleston's voyeuristic view through the trees of a female figure in stone pointing an instrument toward a spherical object (plate 32) also transforms the experience of sculpture into that of witnessing an act, but only partially, for we will never fully understand its meaning from the distant vantage point provided. Thus a traditional gesture of recording something from the past takes on a quality of modern urban experience in the street in which, as passersby, we inevitably witness events by entering the narrative somewhere in the middle, never to learn a story's origin or resolution.

The role of gesture is seductive in the extreme in leading us into the drama of sculpture. In *Paris,* 1951 (plate 29), Robert Frank responds to the empty flirtations of a

painted carousel figure with bared breast and flowing tresses. But he is only following, and in the process subverting, what his great mentor Walker Evans revered in the Confederate soldier who perpetually raises the American flag in *Battlefield Monument, Vicksburg, Mississippi,* 1936 (plate 23). Not only Frank's conception of a personal union with sculpture but those of Abbott, Friedlander, Benson, Adams, Eggleston, and even Warhol seem to stem from Evans' personal communions with monuments.

The many studies that Steichen made of Rodin's sculpture of *Balzac* (plate 18) express a parallel communion of the photographer with sculpture. Steichen unavoidably meets Rodin head-on, but he communes in another way with the novelist, by seeming to trail after him as he disappears in the garden park. The genesis of this sculpture was a melodrama in itself. After many interpretive trials, which satisfied no one, Rodin finally enveloped the figure of Balzac, who was hardly ethereal as man or writer, in a great cape, as if to transform him into pure spirit and eradicate his physical side altogether. Steichen reinforces this intention by having Balzac's effigy appear in the half-light as a completely self-absorbed, ultimately elusive mirage.

What is striking is Steichen's ability to sacrifice the entire substance of the three-dimensional original, the tactile qualities of which were questionable even to Rodin's public, in order to test the power of the silhouette, as Rodin himself had done. This was nothing new in the photography of sculpture in 1911, even though Steichen and his "pictorialist" contemporaries thought that they were bringing to their mechanical medium an element of art that had gone unexplored. The pictorialists were simply unaware that the battle for such artistic effects had been fought and won from the moment of photography's birth.

Bayard's pictures of sculpture, among the first that he exhibited to the public in 1839, enjoyed a critical response that illustrates how easily romantic terminology of painting could be applied to photographic experimentation. It also suggests the terms in which the first photographs of sculpture were experienced. The critic Francis Wey, a champion of Courbet and committed to an art of visual concreteness, seemed less to be looking than to be imagining Bayard's photographs. But we can believe his eyes. The photographed figurines, he wrote, were wrapped in a "fine curtain of mist. . . ." Their forms had "the fantasy of dreams, . . . [being] both distant and complete."[11] There would hardly be a better way to characterize Steichen's rendition at 4:00 A.M. of Rodin's *Balzac.*

From the beginning the power of sculpture, as photographed, lay beyond the experience of concrete, desirable objects. The camera image, however vague and strange it might be, retains something absolutely essential in reinforcing our experience of actual three-dimensional models, perhaps because most photographers realized they had to

invent a means to replace the lost sense of touch. This produced another tantalizing experience, especially with the human figure. In photographs, sculpture appears before us in an arrangement in light that simulates tactile values but remains something forever beyond our reach. We are asked by photographs of sculpture to regard looking alone as sufficient to grasp the objects in question, and at that, only one aspect of them at a time.

Thus in viewing photographs of sculpture we play perpetually the frustrated lover or striving spiritual seeker who must find comfort in signs, gestures, aspects, fragments, and angles of vision from which to imagine the full-bodiedness of actual possession or understanding. The endeavor could hardly be more romantic, for it combines public display with the greatest intimacy. How tantalizing Charles Sheeler's *Fragment of a Head of King Akhenaten* (plate 24) is in this respect. Against a dark ground, a nose casts its shadow over chiseled lips, slightly pursed at the corners. There is nothing where the eyes should be; only the gentle protrusion of a cheek remains to testify to this moment of new humanism in Egyptian heroics. It was sufficient to engage Sheeler's love of linear simplicity, for he rendered the fragment by making its edges burn away all that might impinge upon its unshakable presence.

Remarkably, to this day, such contradictions regarding the fullness of meaning that can be extracted from fragments continue to compel every kind of photographer. Why did Lee Miller photograph Joseph Cornell's *Object* (plate 21)? What did she glean from the baby doll's head stuck with threaded needles and floating in a goblet of clear liquid, which is encased in a Victorian bell jar? The little face, stamped from a mold, is like that of a genie, a supernatural vision appearing in translucent space sealed from contact like a tomb. This image of 1933, which Cornell inscribed to Marcel Duchamp, has the gloss of glamour magazines; yet its perverse cruelty is something to which Miller must have been attracted. As a photographer for *Vogue* managing to be among the first to enter Buchenwald and Dachau, she would encounter it again.[12]

In Frederick Sommer's vision of *Ondine* (plate 26), presumably named to allude to the water nymph, the same quality of a strife-ridden dream emerges from the desiccated rubber doll's arm stuffed with the leg of another human facsimile, lying on a weathered wooden board. The assembling of these parts, or their simple discovery, may have called to mind some fantastic anatomy washed ashore and conveying nymphic qualities. Similarly, Hans Bellmer's *Poupées* of abandoned "girls," assembled by the sculptor/photographer from variously imagined anatomies, suggest a poetics of violation, dismemberment, and death. Sommer's little rubber arm is hardly less benign.

From the beginning sculpture was a touchstone against which photographers measured psychological revelations. Take Louis-Emile Durandelle's record of a few of the scores of theatrical masks that would find their way into the sumptuous decor of the new Paris Opera (plate 12). We confront these faces, but they do not engage with

us. Here, as in all great decoration, physiognomies are meant to be nothing more or less than figments of feeling, ornamental metaphors for pure psychic energy. Louis-Rémy Robert discovered the same truth in the figures surrounding the Pool of Neptune at Versailles (plate 4).

Many sculptures suggested avenues for the psyche, particularly by extracting things people were used to seeing in cathedrals, museum halls, chateaus, parks of kings, or public gathering places and by making images of them. Now brave soldiers on horseback, decorative personages of obscure myths, and fables were photographs summoning history, conveying the illusion of being face-to-face with past time, holding in their glistening forms the animus of an ancient civilization. Abstracted from their sources and further fractured by camera art, sculpture retrieves for the imagination whole cultures at a glance.

Nowhere is this more forcibly felt than with the sculpted head, which imposes on the photographic imagination a presence as formidable as a living countenance. Thomas Eakins' composition of the bust of his father, Benjamin Eakins, by Samuel Murray (plate 17) grasps the older man, rendered by the sculptor with the frank realism of a Roman Republican portrait. How sympathetic is the light Eakins allows to fall on the bald pate, on the muscles and sinews of the neck, rendered by Murray with an anatomist's zeal. The portrait conveys information like an autopsy, but Eakins has chosen a conversational angle for the sculpture, one that makes the nudity of the sitter appear as shocking as that in Albert Sands Southworth's self-portrait as an "idealized bust" in daguerreotype,[13] or that of Bayard's mocking self-portrait of 1840 posed as if he were a cadaver waiting to be claimed in the morgue.[14]

A sculpted head gives to the theater of the camera's gaze the illusion that the subject had endured many lives before being photographed. It brings to the lens historical depth and resonance, and gave to photography from its first moments anything but a sense of immediacy or of a thing born in the moment. Rather, through this new technology, dedicated to the here and now, sculpture offered the viewer a means to contemplate the romantic obsession with *then*. To photograph was not only to record, but in some strange fashion to raise the dead from complex and discontinuous time, as an archaeologist might do in pulling from the dust the latest remnant that has pushed its way to the surface.

Sculpture's confrontations with the dead seduce photographers into private meetings face-to-face. Patrick Faigenbaum's *Hadrian,* 1987 (plate 35), is only one of many such attempts to get close to history by scrutinizing its face, with the pinched brow and the canopy of curls that black out the glance that we meet only through Faigenbaum's tight framing and fearful symmetry. In this head the artist introduces us to the source of imperial power, but really to the soul of a man in the same spirit as Marguerite Yourcenar reinvented Hadrian by fabricating his life story in *Memoirs of*

Hadrian. We are as close to Hadrian, or rather to an ancient sculptor's version of his features, as we would be to the face of an examining physician or to that of a confidant or a lover.

Before she turned from a heroic style of portrait photography to work exclusively in video, W. Snyder MacNeil found the same intimacy in medieval sculpture. It contained prototypes for the ennobling vision that she conferred on the heads of her contemporaries. So it is not surprising when she photographed the fragmentary head of a medieval king from Notre Dame in the Cluny Museum (plate 33) that she found a point of view that pays homage to her sources by further humanizing them. MacNeil renders the king's face as if it were surrendering to our glance from behind the surface of the mutilated stone like a lost soul forever veiled from view. The sculpture practically palpitates with translucency in MacNeil's pale platinum print on tracing vellum. The king's eyes are barely visible; yet we cannot deny that he looks back at us through his broken countenance, leaving us to wonder where in fact contact with sculpture actually originates. Surely it is not simply with the chiseled materials themselves, but with an ineffable spirit that miraculously resides within the work. Only certain photographers care to grasp it, as MacNeil does, through diaphanous chemistries. Robert Mapplethorpe discovered this spirit in his vision of Praxiteles' *Hermes* (plate 41), but the feeling was not enough for him. The black ground against the sculpture's almost imperceptible expression calls to mind the mute silhouettes of Wedgewood at his most stylish, and betrays the photographer's own incorrigible sense of chic.

If Mapplethorpe's work makes the past look brand-new, MacNeil's work, like that of Faigenbaum, looks older than it ought to, seems to dwell in a membrane peeled from an ancient organism. This raises a peculiar question as to why certain camera pictures of sculpture from all periods often look downright aged, seem to have been made millennia before the nineteenth or twentieth centuries. Certain images by Daguerre lead us to believe we are witnessing the very dawn of history. His composition of fossil shells, ca. 1837, reminds us that the oldest and most exquisite sculpture in the world first appeared as natural forms that were the result of infinitesimal changes over time. The calcified helixes and coils of the fossils recall the living inhabitants from whose bodies trailed liquid substances that formed the permanent shells for shelter and protection. Thus Daguerre, in choosing fossils among the first things photographed, recorded objects that not only encapsulate immeasurable time, but allude to the essence of the photographic process by showing other ways in which nature managed to imprint itself.

Photography veritably whispers of time's secrets in its choices of sculpture as a subject. Bayard's figurines, swaying like somnambulant dancers on gauzy gray proscenia, are like visitors from a forgotten epoch. Daguerre's fossils sleep in a light that holds the very dust of forgetfulness. When Henri Le Secq, photographing at

Chartres Cathedral in 1851, extracted the lovely figure of the angel holding the sundial (plate 6), he chose it for obvious reasons. The sculpture was beautiful, but also the angel held the instrument that gave meaning to his camera art by measuring time with light. Contemplating the same figure at Chartres over fifty years later, Rodin, with an eye as insistent as a photographer's, cast his own light on Le Secq's subject. His observations not only reveal what it is to look at sculpture, but also suggest certain feelings that lie behind every great photographic confrontation with the art:

> What is this archaic line? . . . I walk around this figure. I study it not for the first time, and as always with insistence. . . . I am willing, like a good workman; my task is to understand. . . . I contemplate. . . . The Angel of Chartres is like a bird perched at the angle of some high promontory; like a living star beaming out in solitude over some great stone foundations. The contrast is keen between this Solitary One and the crowds assembled under the portal, where all is brimmed with moving, sculpted figures. I draw nearer again, then step back to the left, trying to situate the beauty of this adorable being. Now and then I understand. The head seems like a winged sphere. The draperies are admirably supple, surpliced over tunics. What a frame the powerful repose of the buttresses make for it! From the height of his solitude the Angel of Chartres, in the attitude of the annunciator, views the city with joy. He wears time on his breast and offers himself in profile, the body effaced, hovering like an acanthas leaf. How chaste this body is! This is not the Victory of Samothrace who voluptuously shows herself nude beneath the thinly pasted veil of draperies. Here modesty reigns. The garment comments austerely upon the forms without ever depriving them of their grace; only a grave motive could cause a leg or an arm to advance to make a projection. The Angel is a point on the lower part of this immense foundation, like a star in the still obscure firmament. His profile is pious and full of wisdom. He brings the Summation of all philosophies. Time is written upon him like a sentence upon the page of a book. With what self-recollection he holds and shows us time, time that wounds and kills! The profound significance of this gesture is the benevolent, vigilant intention of the sculptor who found and willed it. A sundial is a regulating force: God directs us as it does, ceaselessly intervening in our life by the sun's mediation. This Angel therefore wears upon his breast the law and the measure that come from the sun and from God. Man's daily task becomes divine by being ruled according to the vibrations of that divine light.[15]

Photographers from our own time who are attracted to sculpture seek the same embeddedness in past histories and, I would venture to add, the same "divine light," no matter what their subjects are. When they photograph sculpture they step

into worlds in which they could never have lived, wander gladly in the forests of memory and forgetfulness where human greatness reveals itself. Linda Connor discovered such things in the skilled incisions of a horned deer and smiling crocodile by Egyptian draftsmen in the Valley of the Kings (plate 38). And what tender illumination through platinum printing a photographer like Jan Groover (plate 40) gives to the remnants of horsemen being kissed by maidens, to conversing gods and heroic warriors. Can we believe Rodin's protestations that photographs of monuments are "mute" and allowed him "to see nothing"?[16] The deities who mingle among us through photographs of sculpture reveal themselves as clear and jewel-like, converse mysteriously as the language in the rustle of silk.

EUGENIA PARRY JANIS

Notes

1. Helmut and Alison Gernsheim, *L. J. M. Daguerre, The History of the Diorama and the Daguerreotype* (New York: Dover Publications, 1968), 85. Quotes H. Gaucheraud, a journalist writing in the *Gazette de France*, who summarized Arago's speech to the Académie des Sciences on 7 January 1839. Gaucheraud is referring here to "inanimate nature and architecture."

2. George Gordon, Sixth Baron Byron of Rochdale, *Childe Harold*, iv. 161. Quoted in Thomas Bulfinch, *Bulfinch's Mythology* (London: Spring Books, 1964), 19.

3. Raymond Lecuyer, *Histoire de la Photographie* (Paris: Baschet et Cie., 1945), 23. Gives the authorship of this daguerreotype to the still mysterious Hubert whose *Le Daguerreotype considéré sous un point de vue artistique, mécanique et pittoresque* (Paris: Giroux, Lerebours, 1840) was significant in promoting the technique as an art at its earliest stages of development. See André Jammes and Eugenia Parry Janis, *The Art of French Calotype, With a Critical Dictionary of Photographers 1840–1875* (Princeton: Princeton University Press, 1983), 9–11; and note 31, 110–11.

4. Jean Baudrillard, *The Ecstasy of Communication*, trans. Bernard and Caroline Schutze, ed. Sylvere Lotringer (New York: Semiotext[e], 1988), 62.

5. William Henry Fox Talbot, *The Pencil of Nature* (London: Longman, Brown, Green & Longmans, 1844–46), text for pl. 17.

6. Over several years, Talbot made countless trial exposures of this sculpture bust based on an original in the Townley Collection in the British Museum. One signed and dated "H. F. Talbot 1840" has recently turned up in an album once belonging to the Reverend Calvert R. Jones published by Talbot scholar Larry J. Schaaf, which substantiates that Talbot was working from the plaster at least as early as that time. See Schaaf, *Sun Pictures* (New York: Hans P. Kraus, Jr., 1990), cat. 5, 28. Talbot dated another negative August 9, 1842. Besides the most recent discovery mentioned at the outset, according to Schaaf, three other variants are so far known to survive. The first, with the latter date, appears as pl. 5 in Talbot's *Pencil of Nature*, which was issued in six installments of five images from 1844–46. A version of the bust with the profile facing left is pl. 17 of *Pencil*. A third version in the present volume Schaaf dates ca. 1846. He speculates that it was a necessary variant due to the possible destruction or fading of the original negative. Schaaf states that later examples of *Pencil* contain this third variant instead of the one intended for pl. 5.

7. Talbot, *The Pencil of Nature*, pl. 5. The original handwritten text for this is reproduced in *Pygmalion Photographe: La Sculpture devant la camera*, texts by Rainer Michael Mason, Hélène Pinet and Heinrich Wolfflin (Geneva: Cabinet des Éstampes, Musée d'Art et d'Histoire, 1985), 66–67. As for the mystery regarding what sorts of lighting conditions and how much exposure time was required, one gets a notion from a handbook on daguerreotype, published in 1840, in which a chart compares the "state of the weather," hours of the day, and exposure time. For example: in weather "very brilliant and clear, wind steady from W. or N.W., very deep blue sky, and absence of red rays at sunrise or sunset," exposure time was 15 minutes at 8:00 A.M.; 8 min. at 9; 6 min. at 10; 5 min. at 11 to 1; and after 3:00 between 12–30 minutes. It is worthy of note that with weather that was "quite cloudy, but lower atmosphere, free from vapors," exposure time was 50 min. at 8:00 A.M.; 30 min. at 9; 25 min. at 10; 20 min. at 11 to 1; and after 3:00 *between 50 and 70 minutes*. This alone may explain the popularity of sculpture for early photographers. Everything, of course, depended on the season and the color of the object in question: "the time will necessarily decrease as the summer months approach. Much . . . depends upon the selection of the view; a white marble edifice, for instance, requires less time than darker building." See *Full Description of the Daguerreotype Process as Published by M. Daguerre*, ed. J. J. Mapes (New York: J. R. Chilton, 1840), 16.

8. A fact that becomes more poignant when we learn that Talbot's plaster bust of Patroclus ended up in a rubbish heap in the brewery at Lacock Abbey. See Larry J. Schaaf, *H. Fox Talbot, The Pencil of Nature, Anniversary Facsimile* (New York: Hans P. Kraus, Jr., 1989), Introductory Volume, Notes and Plates, 49.

9. See *Hippolyte Bayard, Naissance de l'image photographique*, texts by Jean-Claude Gautrand and Michel Frizot (Amiens: Trois Cailloux, 1986), pls. 4–8.

10. Benson's photographs documenting this monument were published as *Lay This Laurel: An Album on the Saint-Gaudens Memorial on Boston Common*, essay by Lincoln Kirstein (New York: Eakins Press, 1973). This publication, enriched by the literary and historical research of Kirstein, amounts to Benson's personal tribute to the sculptor, to Shaw, the head of the regiment, and to all who fought and were sacrificed. In addition to some twenty images by Benson, it publishes the names of the members of the regiment, indicates their fates, and relates the events that bore upon its participation in the Civil War and on Lincoln's Emancipation Proclamation. This inspiring book contributed to the production of the recent film *Glory*, which dramatized the story that *Lay This Laurel* outlines so vividly and in such moving detail.

11. Jammes and Janis, *The Art of French Calotype*, 4.

12. This was in April, 1945. See "Her Geometry" in *Women Photographers*, ed. Constance Sullivan, essay by Eugenia Parry Janis (New York: Harry Abrams, 1990), 20–21; and Jane Livingston, *Lee Miller, Photographer* (London and New York: Thames and Hudson, 1989), 76–77, 82.

13. Illustrated in Robert A. Sobieszek and Odette M. Appel, *The Spirit of Fact, The Daguerreotypes of Southworth and Hawes 1843-1862* (Boston: David R. Godine & Rochester, The International Museum of Photography at George Eastman House, 1976), 16. This "ideal type" achieved only through lighting still features all of Southworth's facial idiosyncrasies and thus conforms to the natural descriptiveness of daguerreotype. The portrait is a peculiar form of sculpturizing in early photography, in that it has a real person assume the pose of a neoclassical sculpted bust of himself.

14. *Hippolyte Bayard*, 220–21. This illustrates the three versions of Bayard's bizarre form of protestation to the French government regarding his lack of recognition as an inventor of photography, and the letter from Bayard dated 18 October 1840 which accompanied the image.

15. Auguste Rodin, *The Cathedrals of France*, trans. Elisabeth Chase Geissbuhler (Redding Ridge, Connecticut: Black Swan Books, 1981), 213–14, 223. Translated from *Les Cathédrales de France* (Paris: Librairie Armand Colin, 1914).

16. Rodin, *Cathedrals of France*, 60.

2

WILLIAM HENRY FOX TALBOT

Bust of Patroclus

ca. 1846

salt print from paper negative

8⅞ x 7¼″

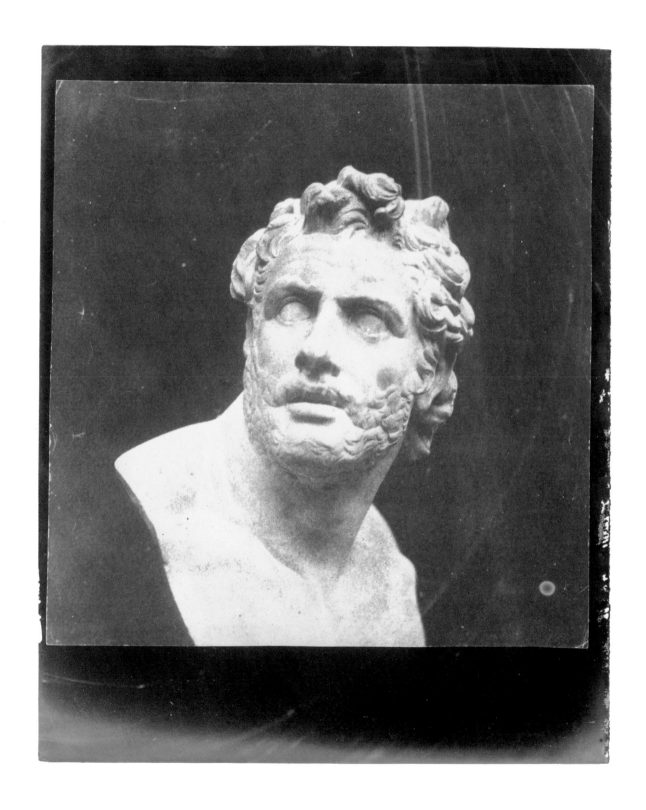

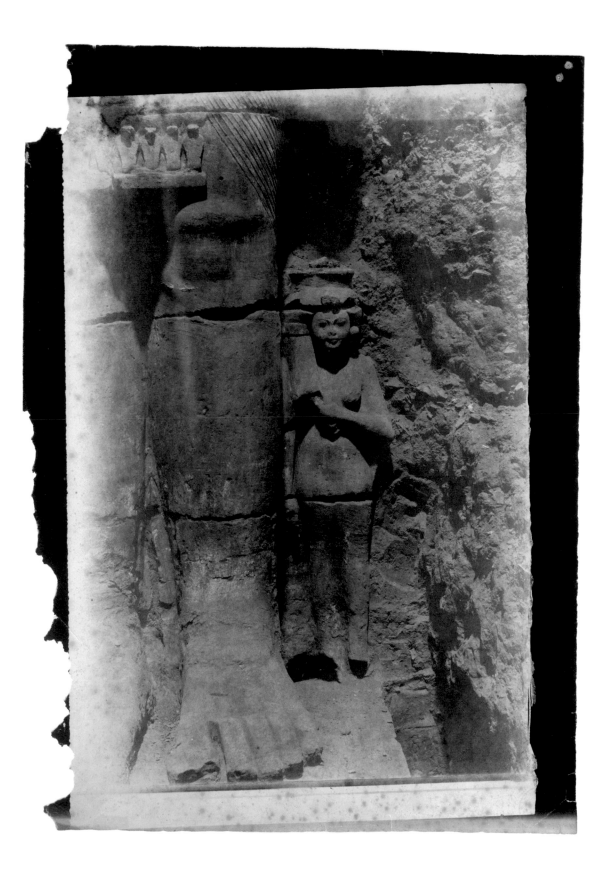

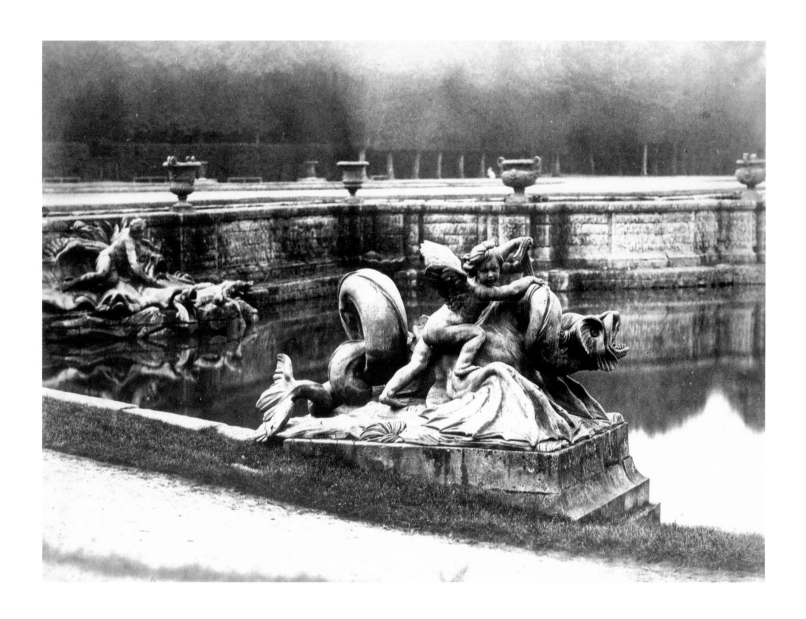

ROGER FENTON

Barbarian Captive, British Museum

ca. 1857

salt print from paper negative

13⅞ x 11¼"

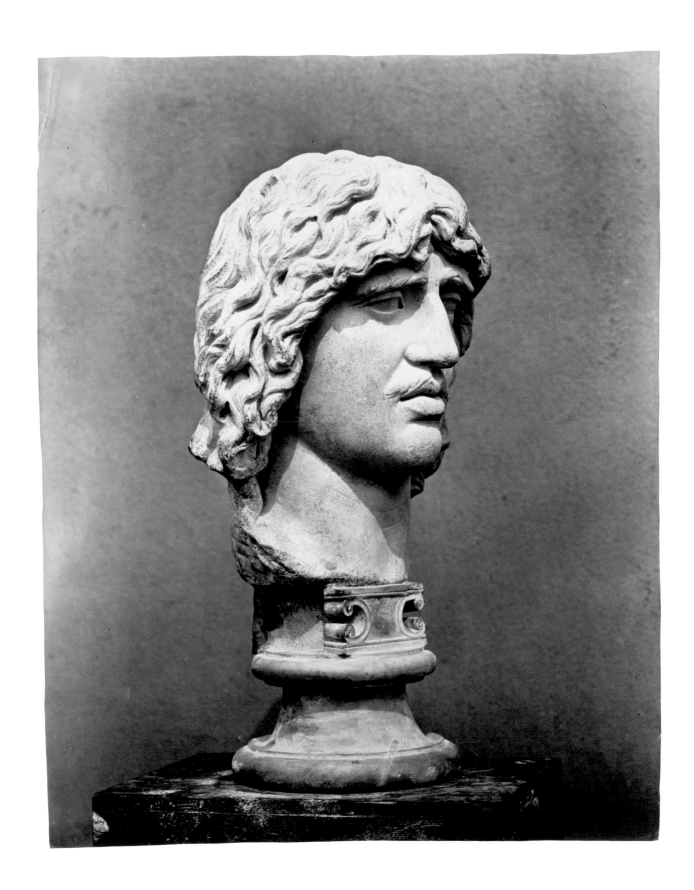

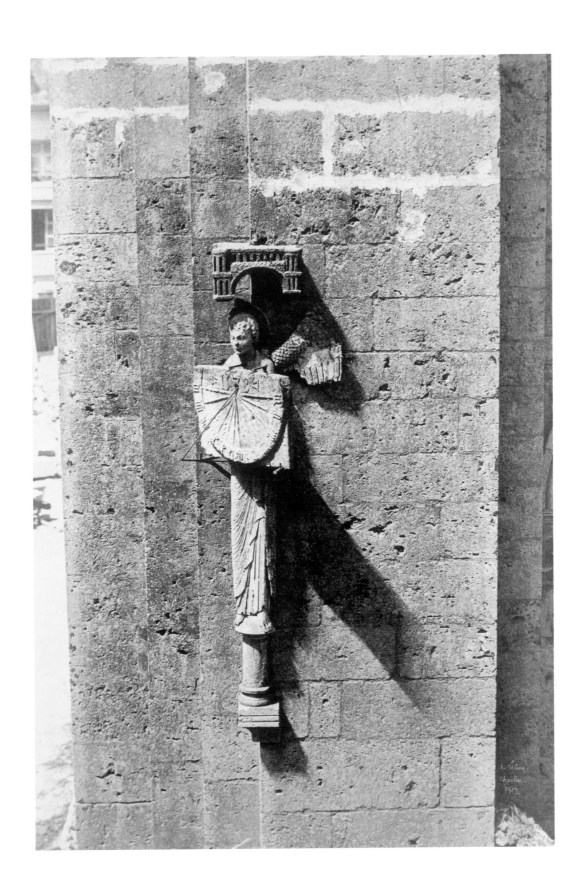

$\dfrac{7}{}$

Charles Nègre

Boreas Lifting Orythia, Tuileries Gardens, Paris

1859

albumen print from wet

collodion-on-glass negative

17⅝ x 14⅜″

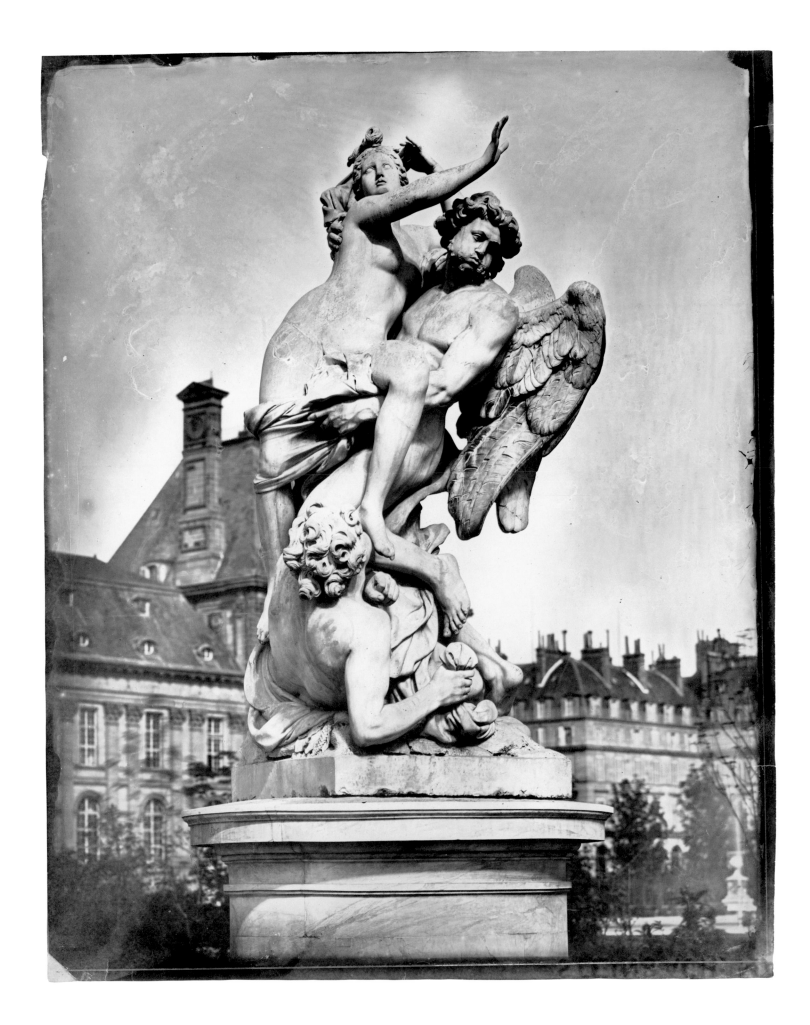

LOUIS DE CLERCQ

A Statue of Oronte, Syria (Seleucie)

1859–60

albumen print from paper negative

10⅞ x 8⅛″

9

PHILIP HENRY DELAMOTTE

"Night," Crystal Palace, Sydenham

ca. 1855

albumen print from wet

collodion-on-glass negative

9⅜ x 6⅜"

CHARLES AUBRY

Still Life with Putto

ca. 1864

albumen print from wet

collodion-on-glass negative

14⅝ x 10⅝″

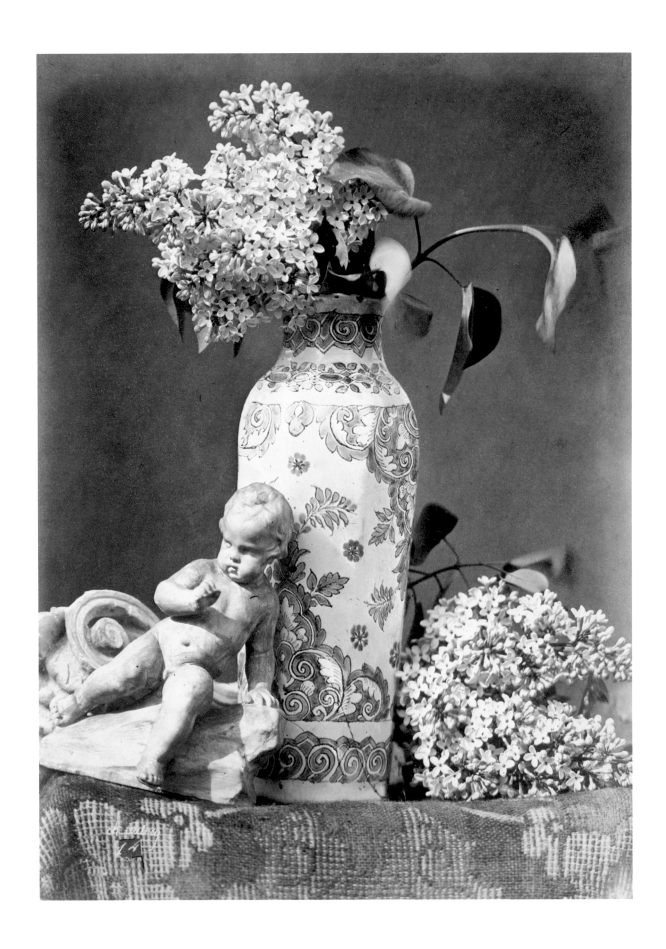

<u>*12*</u>

Louis-Emile Durandelle

Ornamental Sculpture, New Paris Opera

1865–72

albumen print from wet

collodion-on-glass negative

11 x 14¾″

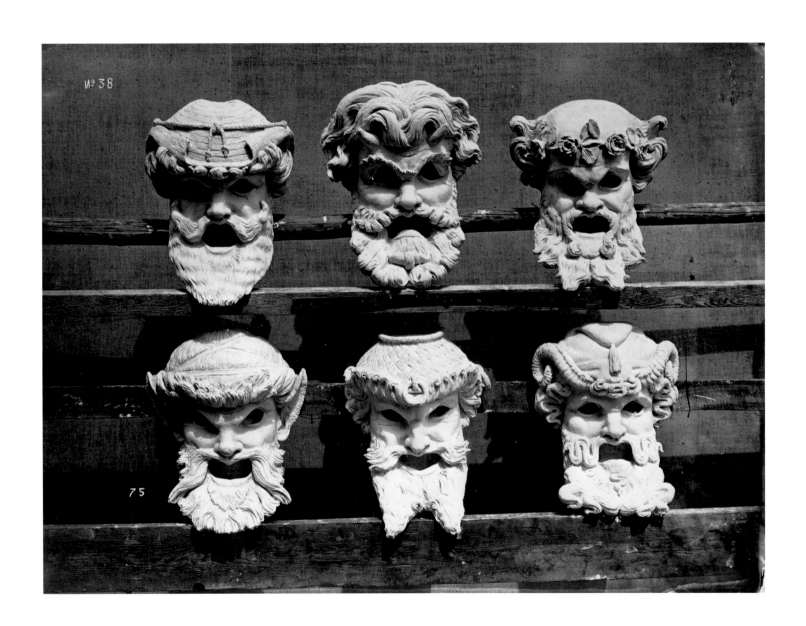

<u>13</u>

DIMITRIS CONSTANTINE

Parthenon Frieze, Acropolis, Athens

ca. 1858

albumen print from wet

collodion-on-glass negative

10⅜ x 14⅜″

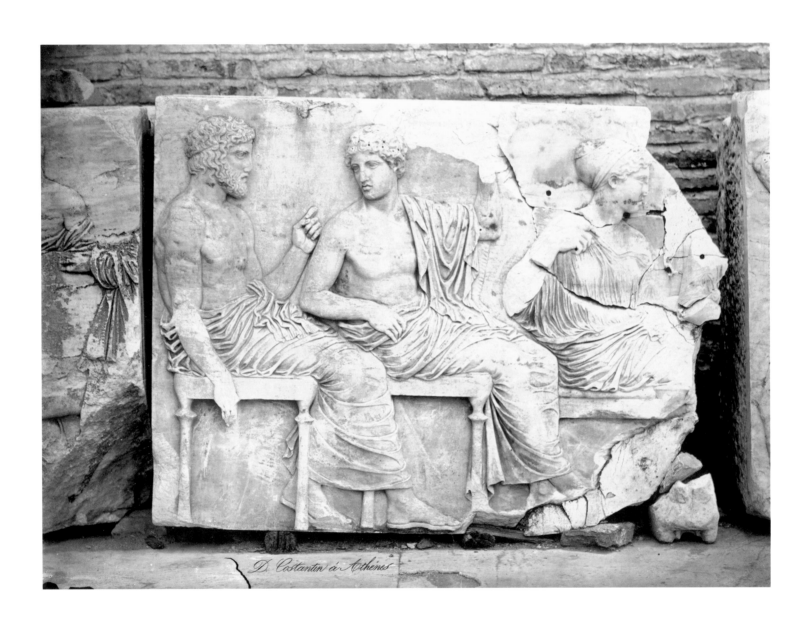

D. Costantin à Athènes

14

W. A. Mansell

Satyr, British Museum

ca. 1865

albumen print from wet

collodion-on-glass negative

11 x 8⅝"

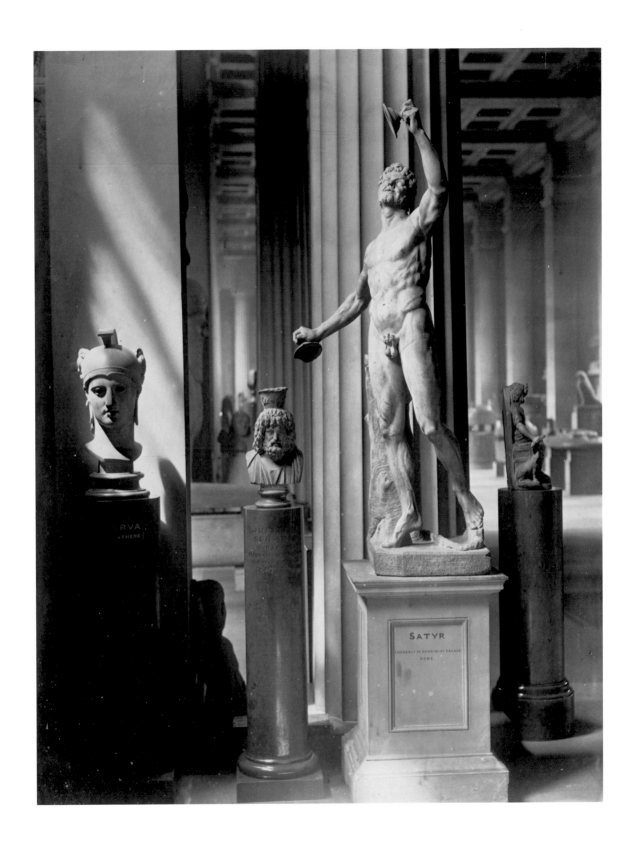

<u>*15*</u>

ADOLPHE BRAUN

"Night," Medici Chapel, Florence

ca. 1880

carbon print

14⅜ x 19″

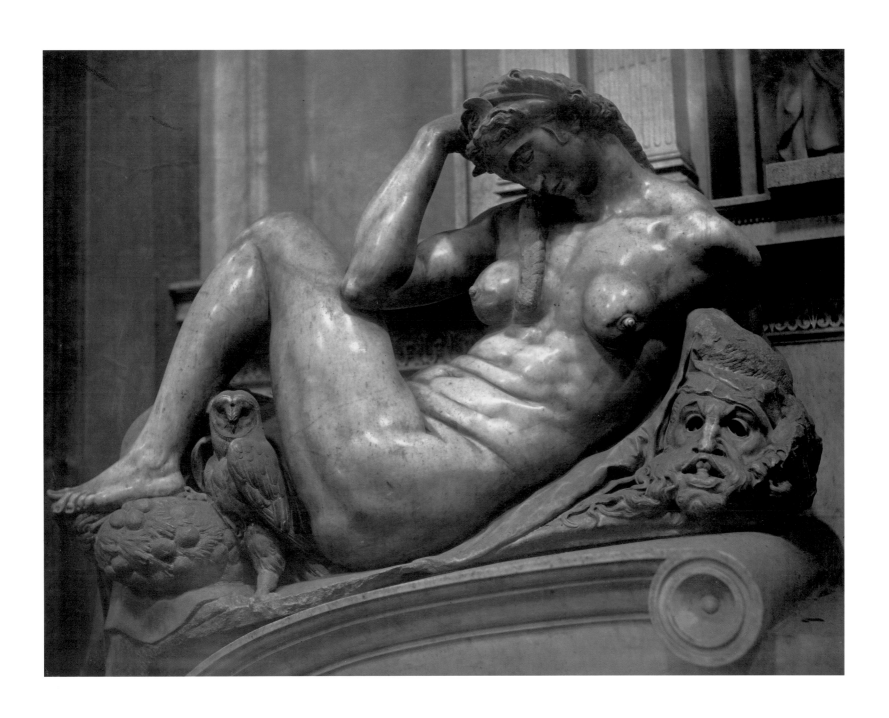

16

FREDERICK H. EVANS

Tomb of Edward III, Westminster Abbey

ca. 1911

platinum print

8⅝ x 6½″

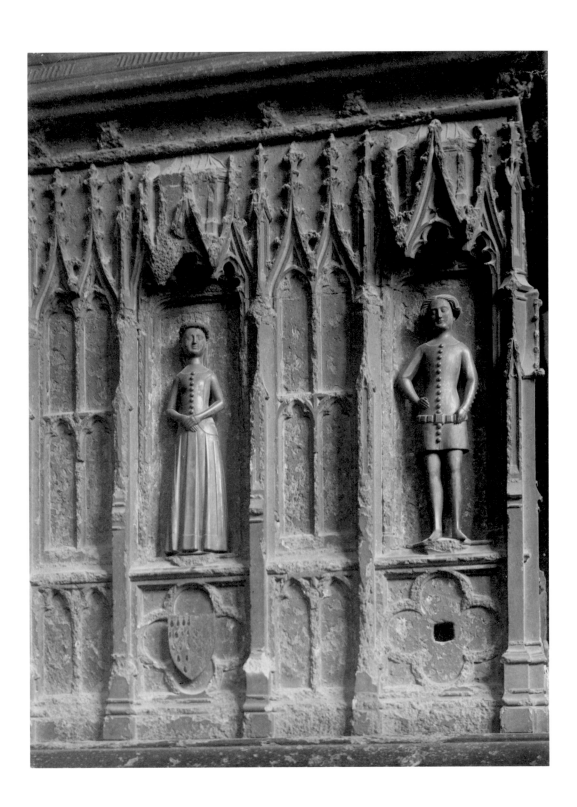

THOMAS EAKINS

Bust of Benjamin Eakins by Samuel Murray

ca. 1890

gelatin-silver print

4 x 2½″

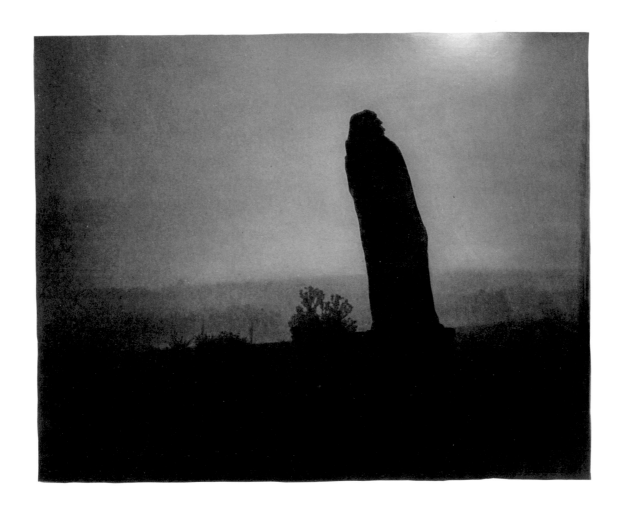

<u>*19*</u>

Eugène Atget

Versailles—Winter

ca. 1922

gold-toned albumen-silver print

8⅝ x 6¾″

<u>20</u>

CONSTANTIN BRANCUSI

The Golden Bird

ca. 1920

gelatin-silver print

9 x 6¾″

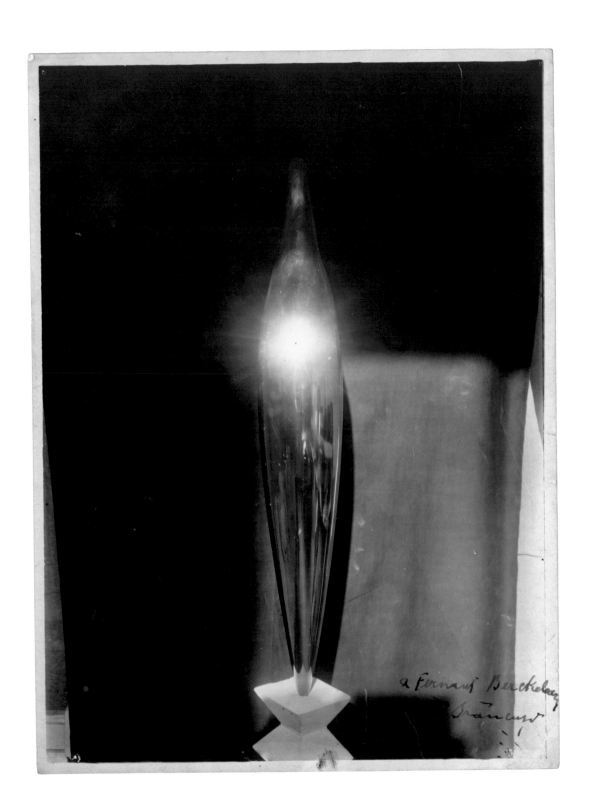

à Fernand Berckelaers
Brâncuși

LEE MILLER

Object by Joseph Cornell, New York

1933

gelatin-silver print

8 x 6¼″

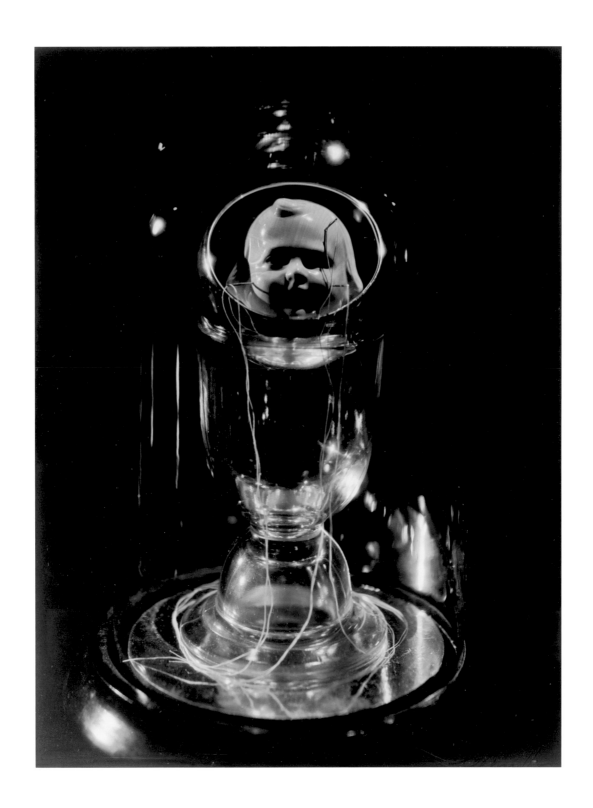

<u>22</u>

BERENICE ABBOTT

Father Duffy, Times Square, Manhattan

1937

gelatin-silver print

9⅜ x 7⅝″

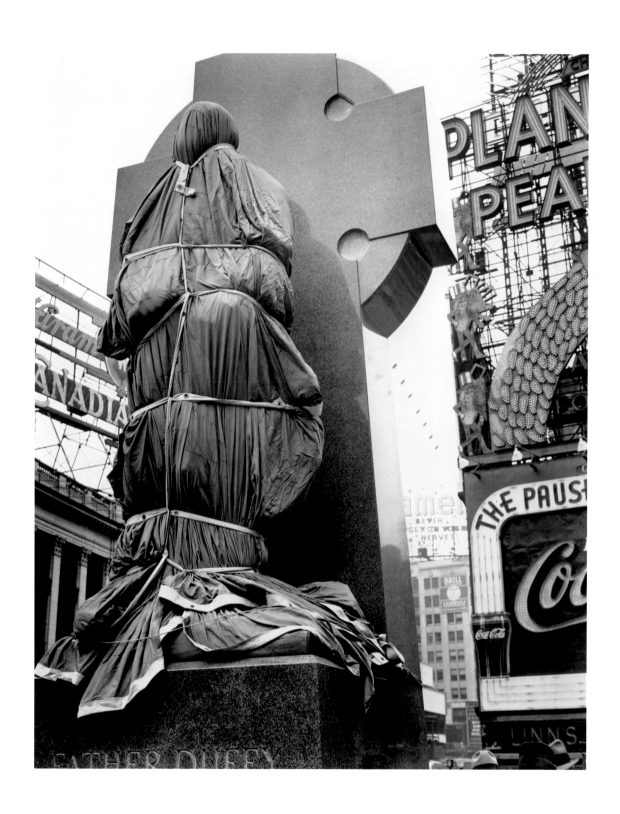

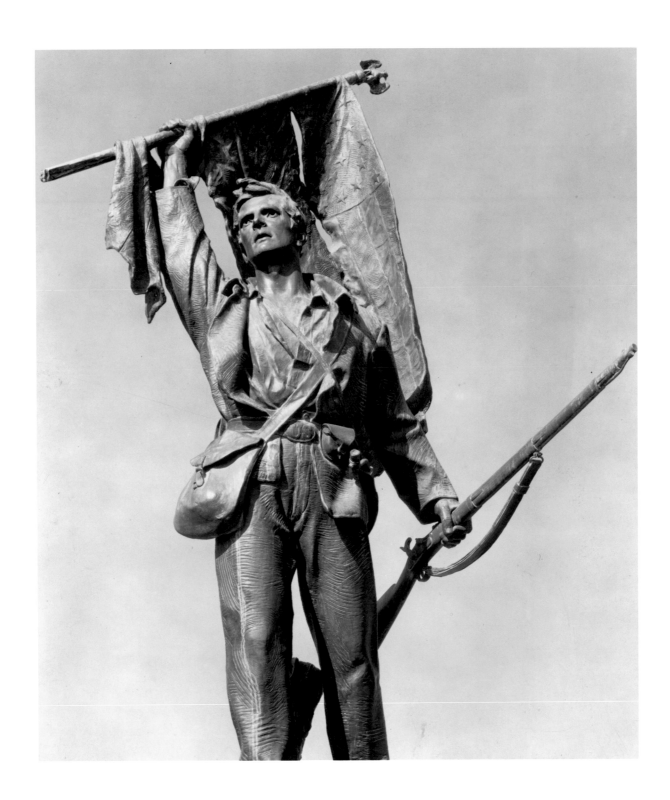

<u>24</u>

CHARLES SHEELER

Fragment of a Head of King Akhenaten,

Egyptian, XVIII Dynasty

1942–45; printed 1982

platinum-palladium print

6⅝ x 4⅜"

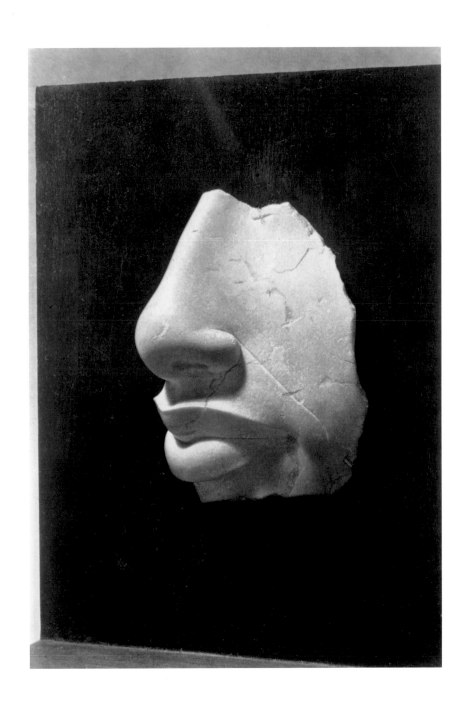

25

HERBERT LIST

Plaster Casts of Classical Sculptures
in the Ruins of the Destroyed Academy of Arts,
Munich, Winter

1945 – 46

gelatin-silver print

11½ x 9″

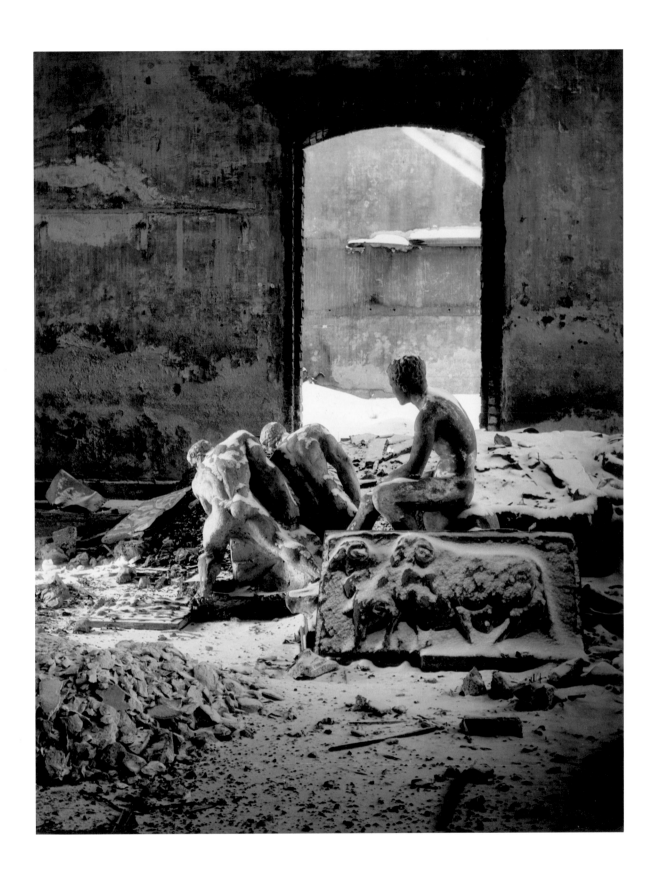

<u>26</u>

FREDERICK SOMMER

Ondine

1950

gelatin-silver print

7½ x 9½″

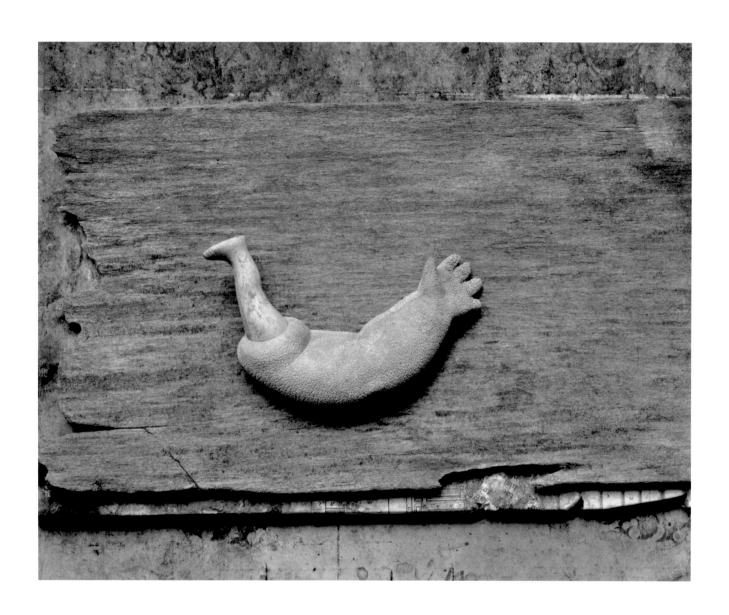

<u>27</u>

Clarence John Laughlin

A Vision of Dead Desire

1954

gelatin-silver print

13½ x 10½"

<u>28</u>

JOHN GUTMANN

Broken Profile and Distant Torso, Paris

1957

gelatin-silver print

9½ x 7¾"

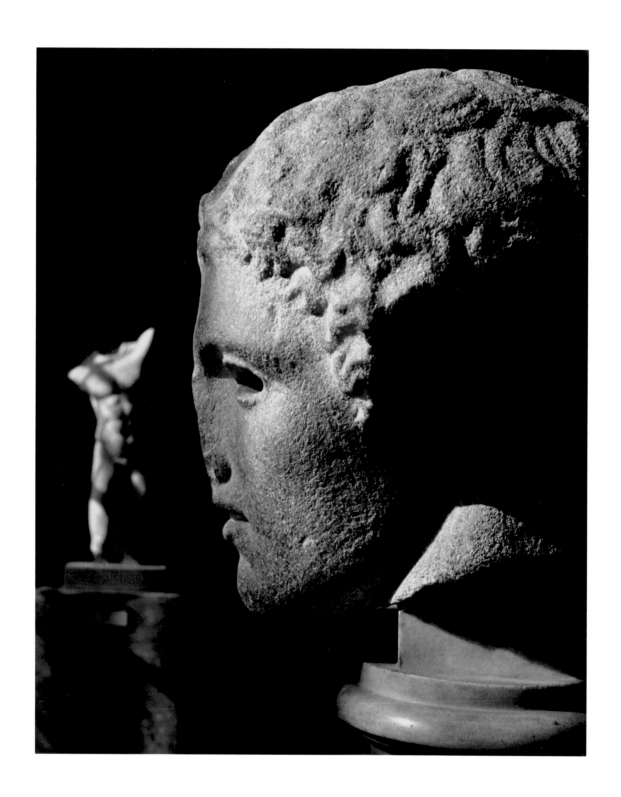

<u>29</u>

ROBERT FRANK

Paris

1951

gelatin-silver print

13⅞ x 8¼"

30

LEE FRIEDLANDER

General George Rogers Clark,

Louisville, Kentucky

1975

gelatin-silver print

8⅝ x 12⅞"

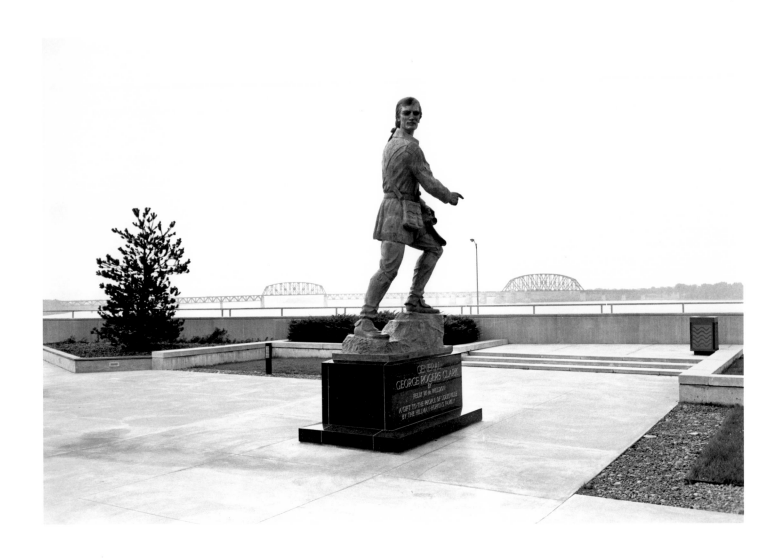

<u>*31*</u>

RICHARD BENSON

Memorial to Robert Gould Shaw and the

Massachusetts Fifty-Fourth Regiment, Boston

1972

platinum-palladium print

12⅝ x 10″

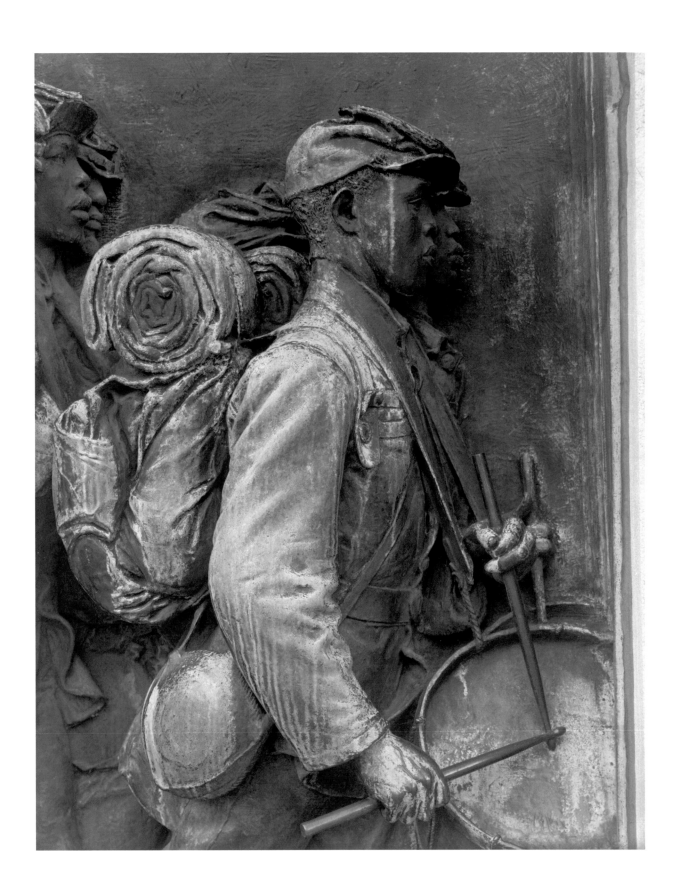

32

WILLIAM EGGLESTON

Untitled

1985

ektacolor-plus print

13¼ x 21″

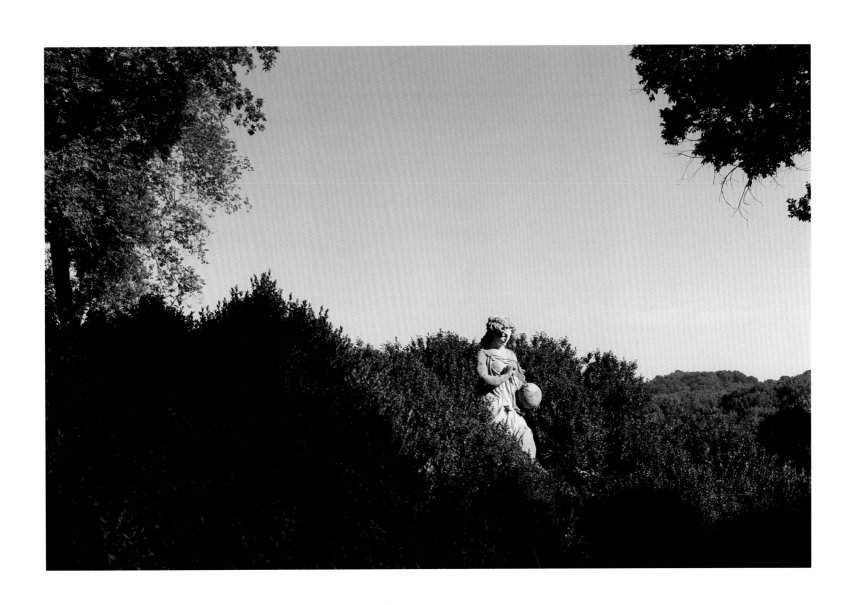

W. SNYDER MACNEIL

Head of King, Cluny Museum

1983–87

platinum print on vellum

20 x 17¼″

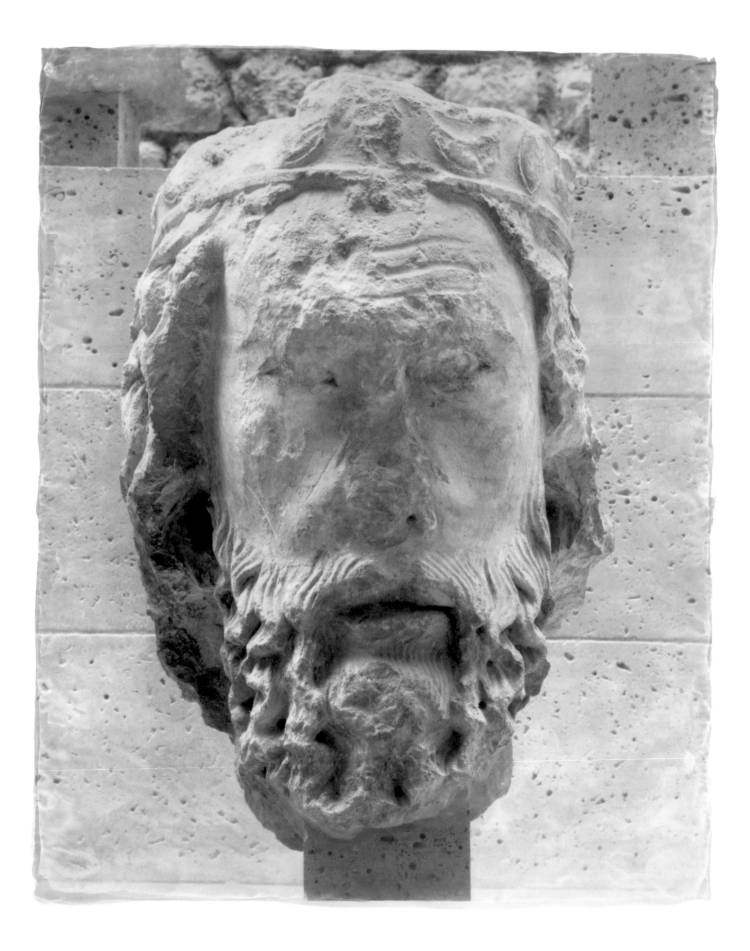

gelatin-silver print

22¾ x 19⅜"

PATRICK FAIGENBAUM

Hadrian, Rome

1987

gelatin-silver print

22¾ x 19⅜"

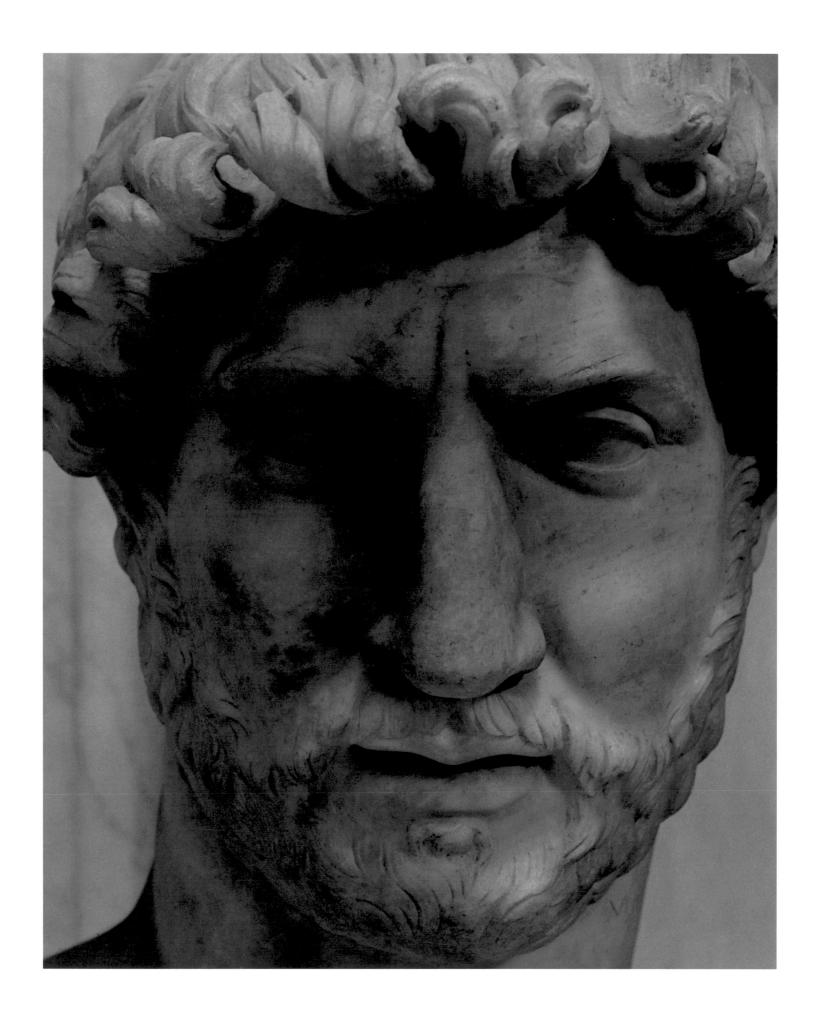

ROBERT ADAMS
Monument to Striking Miners and Their
Families Killed in 1914 by the State
Militia, Ludlow, Colorado
1978
gelatin-silver print
7 x 8⅞"

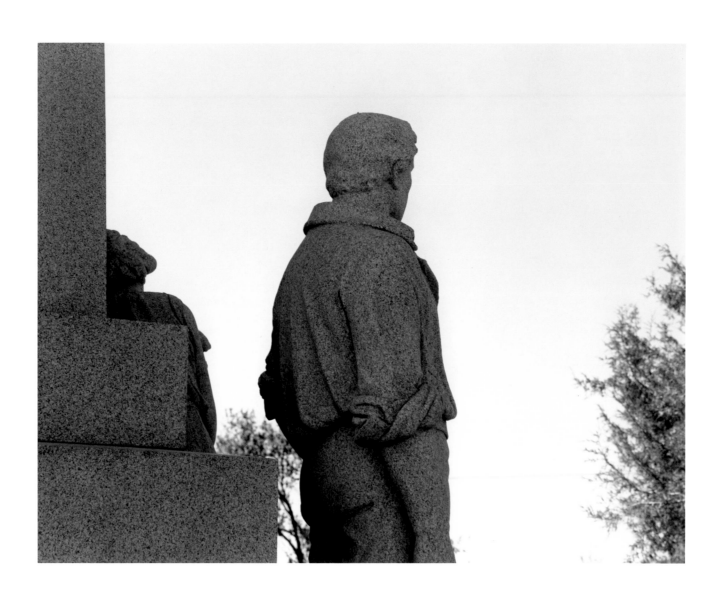

<u>37</u>

ANDY WARHOL

Untitled (Cyprian Sculpture,
Metropolitan Museum of Art)

ca. 1984

four stitched gelatin-silver prints

27½ x 21½"

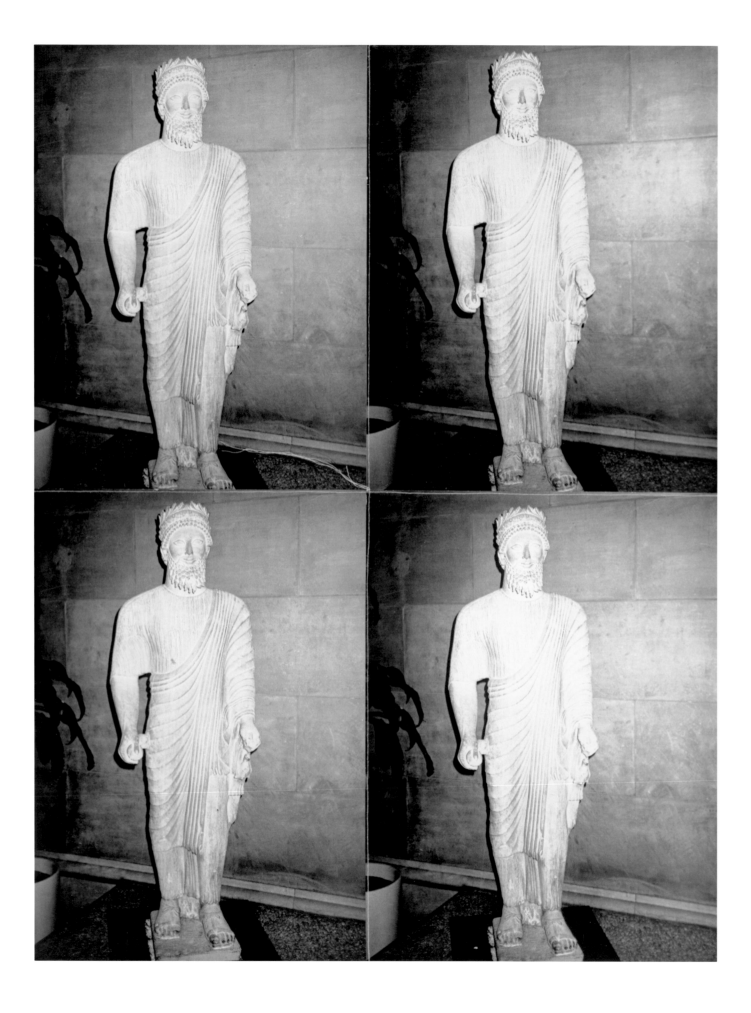

LINDA CONNOR

Crocodile, Valley of the Kings, Egypt

1989

gelatin-silver print

7¾ x 9¾"

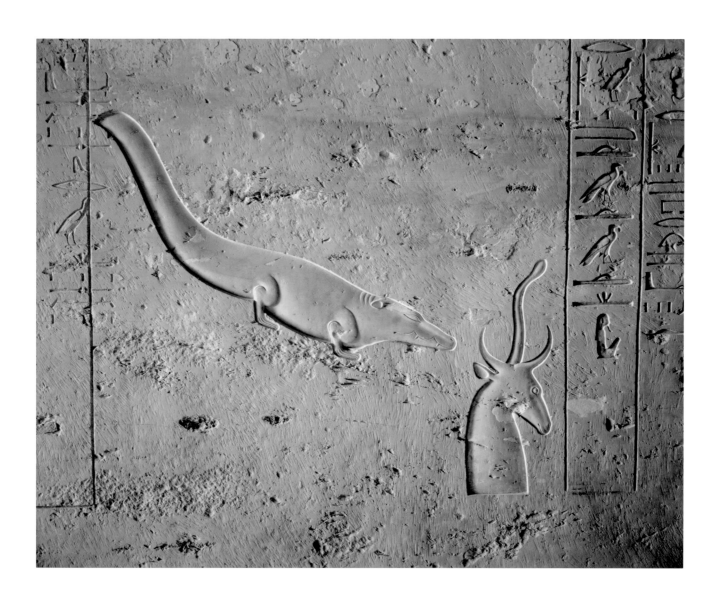

<u>39</u>

Dᴀᴠɪᴅ McDᴇʀᴍᴏᴛᴛ ᴀɴᴅ
Pᴇᴛᴇʀ McGᴏᴜɢʜ

Augustus in Modern Vestments, 1907

1988

cyanotype print

9¾ x 7½″

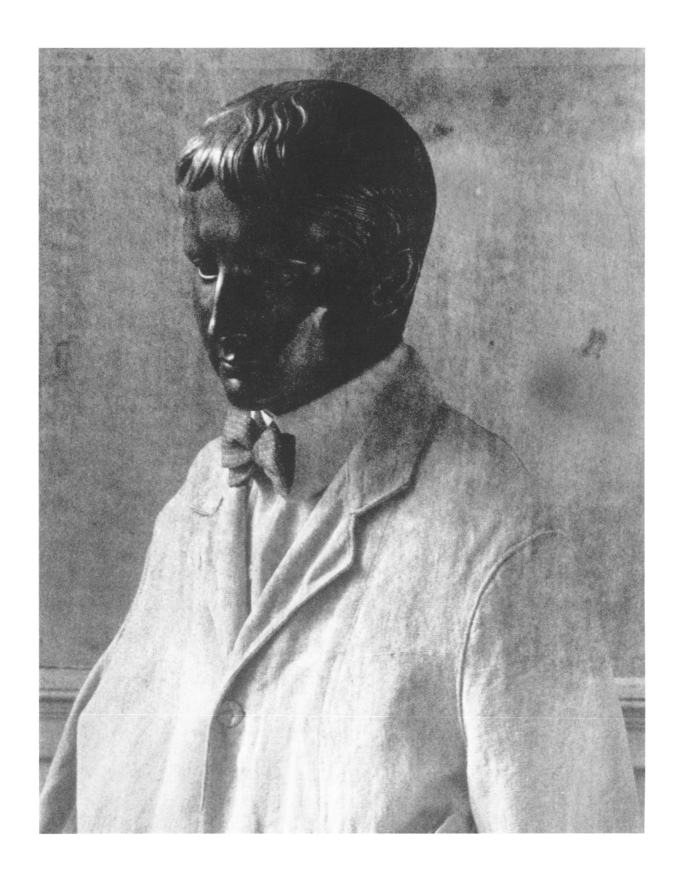

<u>40</u>

JAN GROOVER

Untitled (New York)

1986

platinum print

9⅜ x 7½″

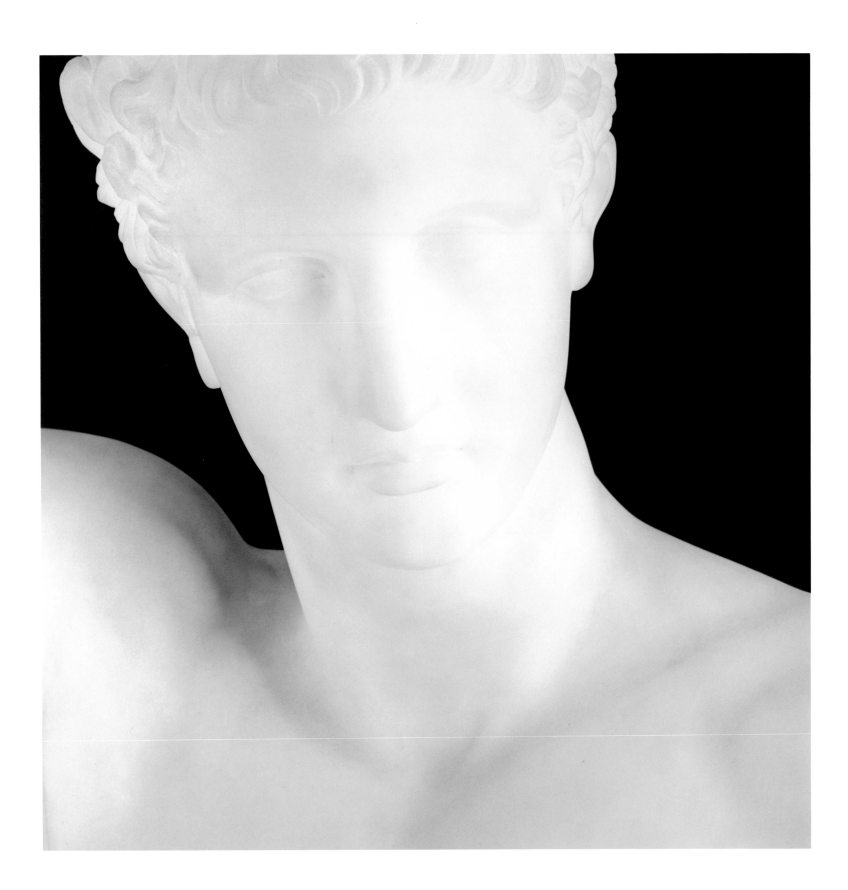

Index to the Photographers

Editor
JEFFREY FRAENKEL

Project Associates
FRISH BRANDT
AMANDA L. DOENITZ
MICHAEL FOLEY
ELIZABETH W. HUTCHINSON
AMY R. WHITESIDE

Design
CATHERINE MILLS

Text Editor
BILL HAYES

Composition
BURCH TYPOGRAFICA

Separations
RICHARD BENSON
THOMAS PALMER

Printing
FRANKLIN GRAPHICS,
PROVIDENCE, RHODE ISLAND

In addition to those artists and estates that
have generously allowed us to reproduce their
photographs, we would like to express sincere
gratitude to the following for advice and assistance:
Gordon L. Bennett, Richard Benson, Bill Berkson,
Sylviane de Decker Heftler, Mary Doerhoefer,
Alain Dupuy, Linda Fiske, Maria Morris Hambourg,
Carol Henderson, Edwynn Houk, Charles Isaacs,
Robert Johnson, Hans P. Kraus, Jr., Mark Leno,
Gerard Levy, Harry Lunn, Peter MacGill, Robert
Mann, Howard Read, David Robinson, Jeff
Rosenheim, Wayne Turner, and Stephen Vincent.

This book is dedicated to the memory of Todd van Bortel.

This publication accompanies an exhibition held at
Fraenkel Gallery, San Francisco, from 13 February
to 30 March 1991.

FIRST EDITION
Printed in the United States of America

Library of Congress Cataloging-in-Publication Data

The Kiss of Apollo: photography & sculpture
1845 to the present /essay by Eugenia Parry
Janis. — 1st ed.
 p. cm.
 ISBN 0-938491-66-0
 1. Photography of sculpture. I. Janis,
Eugenia Parry. II. Fraenkel Gallery.
TR658.3K57 1991
779'973—dc20 90-20595

Published by Fraenkel Gallery in association with
Bedford Arts, Publishers